ETERNAL HOPE

THE JOURNEY OF BOB HOPE

By

VINCENT T HENSLEY

Bob Hope 2024

All right reserved. No part of this publication may be reproduced, distributed, or transmitted in any form or by any means, including prototyping, recording or other electronics or mechanical methods, without the prior written permission of the publisher except in the case of brief quotation embodied in critical review and specific other noncommercial uses permitted.

Copyright© Vincent T. Hensley

Table of contents

INTRODUCTION

Background and Early Influences

Scope and Purpose of Biography

CHAPTER 2

Childhood and Early Ambitions

Birth and Family Background

Early Signs of Talent and Ambition

Struggles and Hardships

CHAPTER 3

Entry into entertainment

First Steps in Show Business

Initial Breakthroughs and Recognition

Formative Years in Industry

Creating a Comedy Empire

CHAPTER 4

Refining the Craft: Developing Bob Hope's Persona

Notable Achievements in Radio, Film

Expand into Television and Other Ventures

The Patriotic Entertainer

CHAPTER 5

Bob Hope and the Military: A Lifetime Dedication

The Effect of USO Tours on Troops

Honors and Recognition of Service

Personal Life and Challenges

CHAPTER 6

Family and Relationships

Challenges and Setbacks

Controversies and Criticisms

CHAPTER SEVEN

Long-term Contributions to Comedy and Entertainment

Bob Hope's Impact on Future Generations

Remembering Bob Hope: Tributes and Memorials

Moral and lesson learned from Bob Hope

INTRODUCTION

Welcome, my reader, to the enthralling biography of the renowned Bob Hope. As you read the pages of this incredible story, you will be taken on an astonishing trip through the life and legacy of one of history's most outstanding performers. Bob Hope was more than a comedian; he was a cultural icon, a source of pleasure and laughter that touched millions world wide's hearts. His narrative exemplifies the power of humor, tenacity, and the human spirit, and it is my pleasure to take you on this incredible journey.

Bob Hope's life, from his modest origins in Eltham, London, to his ascension to become an American icon, is a tapestry of experiences that mirror the growth of entertainment. Leslie Townes Hope, born on May 29, 1903, has had a transformational and triumphant path, distinguished by a dogged pursuit of perfection and a steadfast dedication to his profession. As you read his life, you will find the essence of a man who defined humor for decades while simultaneously serving as a

symbol of hope and inspiration throughout some of history's most difficult periods.

Hope's early years in Cleveland, Ohio, were a mix of adversity and desire. His family, who had relocated from England in quest of a better life, had financial difficulties that young Bob would work to solve. The perseverance he gained during these formative years established the groundwork for his subsequent achievements. Hope first found success in the bright world of vaudeville, sharpening his comic abilities and capturing audiences with his quick wit and contagious charisma. His transfer from vaudeville to radio in the 1930s was a watershed moment, propelling him to national prominence and laying the groundwork for his legendary career.

Background and Early Influences

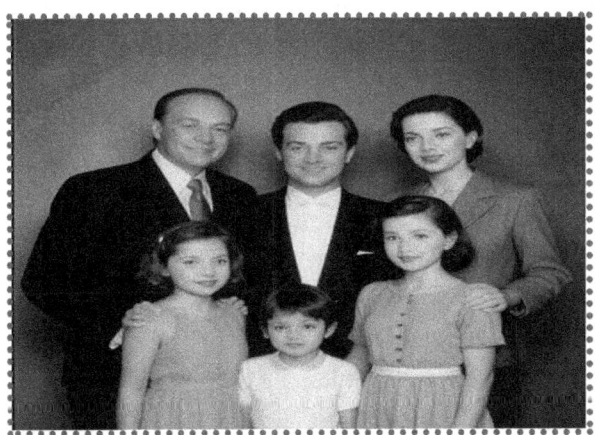

Bob Hope, the legendary entertainer whose name became synonymous with humor and philanthropy, was born Leslie Townes Hope on May 29, 1903, in Eltham, London, England. His parents, William Henry Hope and Avis Townes Hope, were of English origin. The Hopes eventually moved to the United States, settling in Cleveland, Ohio, where Bob spent much of his boyhood. Growing up in a working-class neighborhood, young Leslie, as he was known then, developed an early interest in performance and entertainment. His father, a stonemason, and mother, a light opera singer,

instilled in him an appreciation for the arts and a strong work ethic. Despite the family's limited resources, they supported Leslie's creative endeavors, recognizing his inherent ability for comedy and storytelling. Leslie spent his early years at Fairmount Junior High School, where his exuberant demeanor and ability to make people laugh immediately made him a prominent figure among his peers. His professors frequently recognized his entertainment talent, predicting a career in the show industry for the young youngster.

However, Leslie's route to success was not without challenges. Leslie's father died abruptly when she was 12 years old, causing grief for the Hope family. The loss severely influenced the young boy, requiring him to mature swiftly and accept responsibilities beyond his years. Leslie worked odd jobs to support his family, such as selling newspapers and working as a delivery boy, all while pursuing his education.

Despite his difficulties, Leslie was determined to follow his passion for entertainment. Inspired by the vaudeville acts he saw at local theatres, he began performing as a youngster, polishing his humorous skills and developing his distinct style. During this period, he acquired the stage name "Bob Hope," which became well-known and beloved by audiences worldwide. Bob Hope began his professional show business

career in 1919 at 16 when he joined the Hurley Stock Company, a touring vaudeville team. Traveling from town to town, he acquired crucial experience doing comic sketches, singing, and dancing alongside professional entertainers. It was a pivotal period for Hope, who learned everything he could about the craft of entertaining. As the 1920s dawned, Bob Hope's career took off. He toured extensively with numerous vaudeville shows, honing his comedic timing and building a repertoire of jokes and one-liners that would eventually become his signature. His talent and charisma quickly drew the notice of industry insiders, resulting in opportunities in radio and, subsequently, film. Bob Hope made his radio debut in 1928 on the NBC series "The Intimate Revue," when he demonstrated his quick wit and humorous flexibility to a national audience.

The exposure propelled him to new heights of renown, laying the groundwork for a successful radio career. Throughout the 1930s, Hope became a recognized figure on the radio, captivating listeners with his biting wit and engaging charisma. Parallel to his radio work, Bob Hope began his film career, making his feature debut in the 1934 musical comedy "The Big Broadcast of 1938." Despite his minor role, it signaled the start of a successful cinema career that would last

five decades. Hope's career rose with each succeeding part, cementing his status as one of Hollywood's most bankable and versatile actors.

Despite his growing fame, Bob Hope remained true to his beginnings, never forgetting the ideals his parents and upbringing instilled in him. His generosity and commitment to humanitarian causes became defining characteristics of his legacy, as he used his celebrity and riches to help people in need. Hope's charitable endeavors, whether entertaining troops overseas or raising funds for medical research, won over millions of people and established his place as a revered figure in American culture. By the time he died on July 27, 2003, at 100, Bob Hope had left an everlasting effect on the entertainment industry and beyond. His talents for humor, passion for public service, and unwavering optimism have inspired generations of artists and philanthropists to this day.

Scope and Purpose of Biography

Few names in entertainment history are as revered and admired as Bob Hope's. His legacy as a comedian, actor, and philanthropist is imprinted on the collective consciousness of centuries past and present. Despite all of his praises and honors, there is still a strong desire to delve further into this iconic figure's life and times, untangle the nuances of his persona, and show the everlasting impact he had on the globe. The scope of this biography goes well beyond a simple retelling of events or a list of accomplishments. Instead, it aims to create a course through the various aspects of Bob Hope's life, following his rise from humble origins to international recognition.

From his early years in Cleveland, Ohio, to his rise to prominence in Hollywood and beyond, Hope's life is a tribute to the limitless potential of the human spirit. At its core, this biography has two purposes: to honor Bob Hope's remarkable legacy and to provide readers with a glimpse into the soul of a man whose influence extended

beyond entertainment. Through meticulous research, eyewitness experiences, and analytical analysis, we hope to vividly portray Hope's character, exposing the successes and struggles that shaped his incredible journey.

One of the key themes running through this biography is the concept of resilience in the face of hardship. Bob Hope epitomized the human spirit's tenacity from his early trials as an immigrant in a new country to the formidable hurdles of navigating the harsh world of show business. He often beat the odds, rising above defeats to emerge more robust and more determined than before. Furthermore, this biography delves into the multiple nature of Bob Hope's persona, peeling aside the layers of humor and charm to expose the depths behind it. While Hope was best known for his quick wit and infectious laughter, he was also a man of depth and substance, motivated by a strong sense of purpose and a desire to make a difference in the world. His relentless efforts on behalf of the men and women in the military forces, his steadfast devotion to philanthropy, and his

unflinching optimism in the face of tragedy all demonstrate the breadth of his character. Furthermore, this biography seeks to place Bob Hope's life within the larger framework of American history and society.

As a witness to some of the most turbulent events of the twentieth century, Hope had a unique role in defining the zeitgeist of his day. From the Great Depression to World War II, from Hollywood's golden period to the start of the television era, his work crossed with watershed moments in the nation's collective consciousness, leaving a lasting mark on the cultural landscape. In essence, this biography is more than just a story about one man's life; it celebrates the human spirit and the eternal power of laughter to break down barriers and bring people from all walks of life together. It demonstrates Bob Hope's humor's timeless appeal and the lasting relevance of his message of hope and optimism in a changing world.

As readers begin on this trip through Bob Hope's life and times, may they be inspired by his unwavering spirit, elevated by his contagious laughter, and reminded of the

immense impact that one person can have on the world. Hope himself said, "Thanks for the memories.

CHAPTER 2

Childhood and Early Ambitions

Bob Hope's journey from a working-class neighborhood in Cleveland, Ohio, to the height of Hollywood stardom and beyond exemplifies the force of ambition and perseverance. Leslie Townes Hope, born on May 29, 1903, grew up with a sense of wonder and interest in his surroundings. Growing up in a busy household with his

parents, William Henry Hope and Avis Townes Hope, and six siblings, Hope learned the importance of hard work and endurance. Hope had a natural talent for performance and entertainment at a young age. He was always the center of attention, whether amusing his family with impromptu plays and jokes or his students with quick wit. Recognizing his aptitude, his parents pushed him to follow his passion for show business, instilling in him a belief in the power of dreams and the significance of taking advantage of possibilities. Despite the Hope family's financial difficulties, young Leslie remained steadfast in his goal of an entertainment career. From the time he stepped onto the stage at Fairmount Junior High School, where he attended lessons, it was evident that he was destined for greatness. His charisma and stage presence enthralled spectators, cementing his reputation as a natural-born entertainer.

Leslie's ambitions grew even more vital as he approached adolescence. Inspired by the vaudeville shows he had witnessed at local theaters, he fantasized

about life on the stage, where he could share his gift for laughter with the public.

Determined to make his aspirations a reality, he devoted himself entirely to developing his trade, spending countless hours practicing his routines and studying the techniques of the great comedians of the time. Leslie joined the Hurley Stock Company, a touring vaudeville team, when he was 16 in 1919. Traveling from town to town, he acquired crucial experience doing comic sketches, singing, and dancing alongside professional entertainers. It was a formative era for Leslie, who took up everything he could about the entertainment industry, studying from the greatest. Despite the arduous demands of touring, Leslie excelled in vaudeville, perfecting his comedic timing and building a repertoire of quips and one-liners that would eventually become his signature. His hard work and dedication quickly drew the notice of industry insiders, leading him to opportunities in radio and, finally, film. Leslie remained steadfast in pursuing his passion for entertainment throughout his adolescence and early twenties.

Whether playing in dilapidated theatres or small hotel ballrooms, he poured his heart and soul into every show, knowing that each one took him one step closer to his goals. By the mid-1920s, Leslie had fully embraced his theatrical persona as Bob Hope, a name that would soon be associated with laughter and amusement. With his contagious charm and quick wit, Hope rapidly became a fan favorite, receiving glowing reviews for his performances nationwide in vaudeville houses and theaters.

As Hope's star rose, so did his ambitions. With each new opportunity that came his way, he pushed himself to new heights, continually attempting to improve and innovate his performance. Whether perfecting the craft of radio comedy or moving to the big screen, Hope addressed each obstacle with tenacity and confidence in his ability. Hope debuted in 1934 with the musical comedy "The Big Broadcast of 1938," launching a prolific film career lasting five decades. With each successive part, he demonstrated his acting flexibility and proved that he was more than just a comedian.

From screwball comedies to heartbreaking tragedies, Hope showed a variety and depth that few expected, cementing his reputation as one of Hollywood's most bankable performers.

However, despite his success in the entertainment industry, Hope never forgot his humble roots or the ideals instilled in him by his parents. Throughout his life, he remained true to his roots, never losing sight of the value of hard labor, perseverance, and humility. Probably more than anything else, these characteristics endeared him to millions of followers worldwide and solidified his status as a true icon of American popular culture. Hope once famously stated, "I've always been in the correct place and time. Of course, I guided myself there." Indeed, his rise from a young boy with high goals to a well-known entertainer was a monument to his unwavering desire and self-belief. Even though he is no longer alive, his legacy motivates future generations to follow in his footsteps and pursue their aspirations, no matter how difficult they may appear.

Birth and Family Background

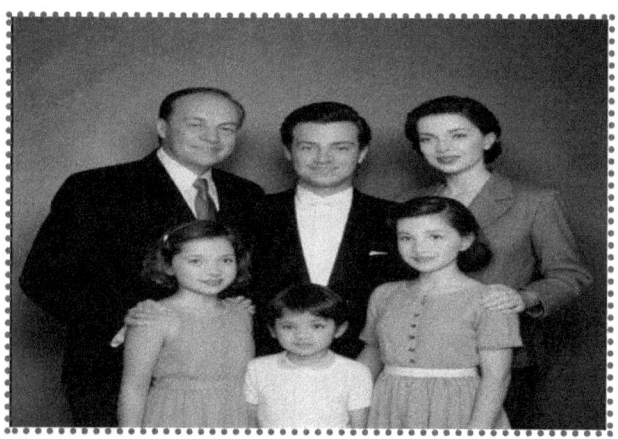

Bob Hope was born Leslie Townes Hope on May 29, 1903, in Eltham, London, England, as the fifth of seven children of William Henry Hope and Avis Townes Hope. Bob's grandparents lived in England for years, and the Hope family traced their roots there. However, fate would eventually lead them across the Atlantic to the shores of America, where their narrative would take on new dimensions. Bob's father, William Henry Hope, was a stonemason by trade, noted for his skilled

craftsmanship and strong work ethic. Born in Weston-super-Mare, Somerset, England, he had a tough drive and quiet tenacity that would serve him well throughout his life. Bob's mother, Avis Townes Hope, came from a family of entertainers with origins in light opera and theatre. Her love of the arts and vibrant spirit would make an indelible impact on her son, molding his fate in ways he could not have imagined.

As a young marriage, William and Avis Hope hoped to create a better life for themselves and their growing family. With opportunity beckoning over the Atlantic, they dared to relocate to the United States for a better future. In 1908, they took sail for America, leaving behind the familiar comforts of England in search of new beginnings in the land of opportunity. Upon arrival, the Hopes landed in Cleveland, Ohio, a booming industrial metropolis overflowing with immigrants worldwide. In the middle of the rush and bustle of city life, they built a new home for themselves and their children, instilling in them the qualities of hard labor, perseverance, and drive. Despite their challenges as newcomers in a foreign land,

the Hopes remained steadfast in pursuing the American dream, determined to carve out a better life for themselves and their children. Growing up in Cleveland's vibrant city was an adventure in and of itself for young Leslie Townes. Surrounded by the sights and sounds of urban life, he took in everything the city had to offer, from bustling markets to exciting theatres. It was here, amidst the hustle and bustle of city life, that he first discovered his love for performance and entertainment, captivated by the magic of the stage and the power of laughter to transcend barriers.

As the years passed, the Hope family grew in size and stature, with Leslie and his siblings experiencing the joys and challenges of childhood in equal measure. From the simple pleasures of playing in the streets to the trials and tribulations of schoolyard rivalries, they formed bonds of friendship and camaraderie that would last a lifetime. Despite the laughter and tears, unity and purpose always held the family together. Whether gathering around the dinner table for a hearty meal or banding together to overcome adversity, the Hopes were united by their love

for one another and their unwavering belief in the power of family. Leslie Townes Hope's parents' values would shape the course of his life in profound ways. From his humble beginnings in Cleveland to the dizzying heights of fame and fortune, he would carry the lessons learned from his family, drawing strength from their love and support as he embarked on his journey into the unknown. Later in life, as Bob Hope rose to prominence as one of the most beloved entertainers of his generation, he frequently reflected on his humble beginnings and the profound influence his family had on his life.

Whether performing for troops overseas or raising funds for charitable causes, he remained faithful to the values instilled in him by his parents, never forgetting the sacrifices they made to give him the opportunities he enjoyed. Bob Hope once famously remarked, "I've been rich, and I've been poor. Rich is better." Yet, for all the wealth and fame he amassed in his lifetime, his family's love and support remained his greatest treasure.

Early Signs of Talent and Ambition

From the bustling streets of Cleveland, Ohio, to the glitz and glamor of Hollywood, Bob Hope's rise to prominence was propelled by a natural skill and an unwavering desire that distinguished him from his predecessors. Bob Hope, born Leslie Townes Hope on May 29, 1903, to William Henry Hope and Avis Townes Hope, grew up in a working-class neighborhood where opportunities were scarce, and dreams often seemed out of reach. From a young age, he demonstrated a natural flair for performance and a hunger for success, propelling him to fame and fortune. However, it was evident from the moment he could walk and talk that he possessed a skill that would lead him to greatness.

As a toddler, Bob was a bundle of energy and curiosity, constantly investigating his surroundings and taking up every bit of knowledge he could find. Bob was always the center of attention, whether impersonating movie characters or putting on impromptu performances for his family, captivating everyone with his charm and

charisma. It wasn't long before his talent caught the attention of those around him, including his teachers and classmates, who marveled at his ability to make them laugh with his quick wit and infectious humor. Bob rapidly became known as the class clown at Fairmount Junior High School, where he was always ready with a joke or a hilarious anecdote to lighten even the dreariest of days. However, underlying Bob's carefree exterior was a burning ambition and a ferocious determination to achieve. From a young age, he realized he was meant for more than a factory worker or clerk job. He aspired to fame and fortune, to make a name for himself in the entertainment industry, and he was willing to work tirelessly to achieve his dreams.

This drive and determination led Bob to pursue a career in show business despite the skepticism of those around him who questioned his chances of success. Bob threw himself into his passion for performance, honing his skills and perfecting his craft with every opportunity that came his way.

Bob took his first tentative steps into the entertainment world in 1919, at 16, when he joined the Hurley Stock Company, a touring vaudeville troupe. It was a baptism by fire for the young performer, who quickly learned the ropes of the vaudeville circuit, performing comedy sketches, singing, and dancing alongside seasoned professionals.

Despite the difficulties of traveling, Bob embraced the opportunity to learn from the best in the business, soaking up everything he could about the art of entertainment. From Midwest vaudeville houses to Broadway theatres, he honed his comedic timing and developed a repertoire of jokes and one-liners that would later become his trademark. Bob's star continued to rise as the years passed, fueled by his insatiable desire for success and unwavering belief in himself.

He pushed himself to new heights with each opportunity, continually wanting to develop and innovate as a performer. In 1928, Bob made his radio debut on the NBC series "The Intimate Revue," displaying his quick wit and comedic prowess to a nationwide audience. It

was a watershed moment for the young comedian, who rapidly became a fan favorite, receiving glowing reviews for his performances. Encouraged by the success of his radio work, Bob began to pursue possibilities in other mediums, including cinema and television. In 1934, he made his big screen debut in the musical comedy "The Big Broadcast of 1938," launching a prolific film career lasting five decades.

Despite his accomplishments and accolades, Bob remained humble and grounded, never forgetting the values his parents and upbringing instilled in him. He understood that success was a journey rather than a destination, and he was determined to enjoy every step of the way. Bob once famously stated, "I've always been in the right place and time; of course, I steered myself there." Indeed, his rise from a young boy with big dreams to a celebrated entertainer was a testament to his unwavering ambition and unshakeable belief in himself.

Struggles and Hardships

Bob Hope's path to greatness was not without its challenges and setbacks. From humble beginnings in Cleveland, Ohio, to the dizzying heights of Hollywood stardom, Hope faced numerous challenges, each testing his resolve and profoundly shaping his character. Hope was born into a working-class family on May 29, 1903, and experienced his fair share of hardships from a young age.

Growing up in a crowded household with six siblings, he quickly learned the value of resilience and resourcefulness as he navigated the ups and downs of childhood in a bustling city. One of the most difficult challenges Hope faced in his early years was his father's untimely death when he was only 12 years old. Left to support his family at an early age, he embarked on odd jobs to make ends meet, working as a newspaper boy and a delivery boy to help put food on the table. Despite his family's financial difficulties, Hope remained motivated to follow his passion for entertainment. From an early age, he exhibited a natural knack for performance, dazzling audiences with his quick wit and engaging charm. However, despite his skill, success did not come quickly.

Hope endured numerous rejections and disappointments as a young artist attempting to build a name for himself in the harsh world of show business. Auditions were treated with disinterest, roles were sparse, and chances appeared to be limited. Despite this, he refused to give up on his aspirations. One of the most challenging

hurdles Hope faced in his early career was breaking into the realm of vaudeville, which is notoriously tricky for ambitious artists. Night after night, he would take the stage to hone his skills and refine his performance in front of sometimes angry audiences.

However, with each performance, he became more robust and determined, refusing to let the critics or cynics get the best of him. As the years passed, Hope's perseverance began to pay off as he slowly but steadily established himself in the entertainment world. However, even as his reputation rose, he had personal and professional obstacles.

One of the most difficult challenges Hope experienced in his later years was the relentless pressure to retain his success and remain relevant in an ever-changing business. With each passing year, the expectations for fame and money increased, as did the scrutiny of the public eye. Throughout it all, he remained loyal to himself, refusing to sacrifice his integrity or values for fame or wealth. Aside from the hurdles he experienced in his business, Hope also faced personal struggles and

hardships. From failed relationships to health issues, he faced adversity with courage and resilience, never allowing his setbacks or shortcomings to define him. Despite his numerous challenges, Hope's indomitable spirit and unwavering determination carried him through the darkest times, propelling him to heights of success and acclaim that few could have predicted. Even though he is no longer with us, his legacy inspires countless people to persist in the face of hardship and never give up on their aspirations.

CHAPTER 3

Entry into entertainment

Bob Hope's foray into the entertainment world was defined by talent, dedication, and a little luck. From his early days as a struggling performer to his rise to fame as one of Hollywood's most beloved stars, Hope's journey was shaped by a series of pivotal moments and chance encounters that would eventually pave the way for his success. Hope was born Leslie Townes Hope on May 29, 1903, in Eltham, London, England, and a sense of wonder and curiosity about the world marked his early

years. Growing up in Cleveland, Ohio, he developed his affinity for performance at a young age, dazzling audiences with his quick wit and contagious personality. It wasn't until his adolescence that Hope's interest in entertainment took shape. Inspired by the vaudeville shows he had witnessed at local theatres, he fantasized about life on the stage, where he could share his gift for laughter with the public. Determined to make his dreams a reality, he embarked on a journey into show business, armed only with his talent and a burning desire to succeed. In 1919, at 16, Hope took his first tentative steps into the entertainment world, joining the Hurley Stock Company, a touring vaudeville troupe. Traveling from town to town, he acquired crucial experience doing comic sketches, singing, and dancing alongside experienced professionals. It was a formative period for the young performer, who quickly learned the ropes of the vaudeville circuit and honed his craft with each show.

Despite the difficulties of traveling, Hope embraced the opportunity to learn from the best in the business,

soaking up everything he could about the art of entertainment. From Midwest vaudeville houses to Broadway theatres, he honed his comedic timing and developed a repertoire of jokes and one-liners that would later become his trademark. It wasn't long before Hope's talent drew the attention of industry insiders, who recognized his potential as a rising star in the entertainment world. In 1928, he made his radio debut on the NBC series "The Intimate Revue," where he demonstrated his quick wit and comedic prowess to a national audience.

It was a watershed moment for the young artist, who rapidly became a fan favorite and received glowing reviews for his performances. Encouraged by the success of his radio work, Hope began to pursue opportunities in other mediums, including cinema and television. In 1934, he made his big-screen debut in the musical comedy "The Big Broadcast of 1938," launching a prolific cinema career that would last five decades. With each new part, he demonstrated his flexibility as an actor, proving that he was more than just a comic. Hope's

star rose over the years, spurred by his unquenchable desire for success and unyielding trust in himself. With each new opportunity that came his way, he pushed himself to new heights, continually attempting to improve and innovate his performance.

Whether mastering the art of radio comedy or making the leap to the silver screen, he approached each challenge with determination and confidence in his abilities. By the time he died on July 27, 2003, at 100, Bob Hope had left an indelible mark on entertainment and beyond. His talents for humor, passion for public service, and unwavering optimism have inspired generations of artists and philanthropists to this day.

First Steps in Show Business

Bob Hope's path into show business began with minor steps, eventually leading to a decades-long career and an unforgettable influence on the entertainment industry. From his humble beginnings in Cleveland, Ohio, to his breakout performances on stage and screen, Hope's early years were distinguished by drive, resilience, and an unwavering pursuit of his love of laughing. Leslie Townes Hope, born on May 29, 1903, grew up in a working-class neighborhood where chances were limited and goals looked out of reach. Nonetheless, from a young age, he showed a natural talent for performance and an insatiable need to entertain people.

He was always happiest when making people laugh, whether through impromptu skits for his family or by participating in school plays. Hope's interest in entertainment blossomed during his adolescence. Inspired by the vaudeville shows he had witnessed at local theatres, he fantasized about life on the stage,

where he could share his gift for laughter with the public. Determined to make his aspirations a reality, he went on a voyage into show business, armed only with his talent and a strong drive to achieve. Hope joined the Hurley Stock Company, a touring vaudeville team, when he was 16 in 1919. Traveling from town to town, he acquired crucial experience doing comic sketches, singing, and dancing alongside experienced professionals. It was a pivotal era for the young performer, who swiftly mastered the ropes of the vaudeville circuit and fine-tuned his craft with each presentation.

Despite life's difficulties on the road, Hope seized the opportunity to learn from the greatest in the field, absorbing everything he could about the craft of entertaining. From Midwest vaudeville venues to Broadway theatres, he polished his comedic timing and built a repertoire of jokes and one-liners that would eventually become his signature. As time passed, Hope's talent and desire drew the attention of industry insiders, who saw him as a rising star in the entertainment

industry. In 1928, he made his radio debut on the NBC series "The Intimate Revue," where he demonstrated his quick wit and comedic prowess to a national audience. It was a watershed moment for the young performer, who soon gained popularity among listeners and received glowing performance reviews. Encouraged by the success of his radio work, Hope began to look into prospects in other mediums, such as film and television. In 1934, he made his big-screen debut in the musical comedy "The Big Broadcast of 1938," launching a prolific cinema career that would last five decades. With each successive part, he demonstrated his acting flexibility and proved that he was more than just a comedian.

Throughout his career, Hope kept true to himself and his humorous roots, never losing sight of the principles that had guided him since the beginning. Whether performing for troops overseas or raising funds for humanitarian causes, he used his celebrity and fortune to make a difference in the world, establishing a legacy of humor

and love that inspires future generations of artists and audiences.

Initial Breakthroughs and Recognition

Bob Hope's rise to become one of the most legendary figures in entertainment was defined by a succession of early breakthroughs and moments of recognition that carried him from obscurity to celebrity. Hope's career was determined by talent, tenacity, and a little luck, from his early days as a struggling artist to his prominence as a famous comedian and actor. One of Hope's first breakthroughs occurred in 1919, when he joined the Hurley Stock Company, a touring vaudeville team, at 16. Traveling from town to town, Hope acquired crucial experience doing comic sketches, singing, and dancing alongside seasoned pros. During this time, he polished his comedic timing and acquired the sharp wit that would eventually become his trademark.

Despite life's difficulties on the road, Hope's talent and magnetism drew the attention of audiences and industry insiders. In 1928, he made his radio debut on the NBC series "The Intimate Revue," when he showed off his humorous abilities to a national audience. His radio

appearances won him significant exposure and appreciation, cementing his status as a rising star in the entertainment industry. Encouraged by the success of his radio work, Hope began to look into prospects in other mediums, such as film and television. In 1934, he made his big-screen debut in the musical comedy "The Big Broadcast of 1938," launching a prolific cinema career that would last five decades. Hope demonstrated his acting range with each successive part, proving he was more than just a comedian.

Hope's early success was mainly due to his ability to adapt and create in response to changing trends in the entertainment industry. As radio and film became more popular sources of entertainment in the 1930s and 1940s, Hope saw an opportunity to broaden his reach and reach new audiences. His natural charm and humorous talent translated seamlessly into the film, gaining his legions of fans and establishing his place as a household celebrity. However, despite his success in the entertainment industry, Hope never lost sight of the values that had guided him since the beginning. Throughout his career,

he was dedicated to using his platform for good, whether by raising donations for charitable causes or entertaining troops overseas during wartime. His persistent dedication to service and unshakeable resolve to make a difference in the world gained him the respect and affection of millions worldwide. By the time he died on July 27, 2003, at 100, Bob Hope had made an everlasting impression on the entertainment business and beyond. His contributions to humor, dedication to public service, and unwavering optimism continue to inspire generations of performers and viewers, ensuring that his legacy lives on for many years to come.

Formative Years in Industry

Bob Hope's early years in the entertainment world were marked by a blend of skill, hard effort, and an unwavering quest for perfection. From his early days as a struggling performer to his ascension to become one of Hollywood's most beloved stars, Hope's life was shaped by a succession of significant occasions and experiences that would eventually define his career. One of the distinguishing aspects of Hope's childhood was his early exposure to vaudeville, a popular kind of variety entertainment that dominated the entertainment landscape in the early 1900s. As a teenager, Hope joined the Hurley Stock Company, a touring vaudeville team that provided him with crucial experience performing comedy sketches, singing, and dancing alongside seasoned professionals. During his experience in vaudeville, Hope perfected his comedic timing and acquired the sharp wit that would become his signature. Night after night, he mounted the stage, captivating

crowds with his contagious personality and boundless enthusiasm.

His performances received excellent reviews, establishing him as a rising star in the entertainment industry. Despite his success in vaudeville, Hope had goals beyond the theatre. Eager to broaden his reach and reach new audiences, he began to look at changes in other mediums, such as radio and movies. In 1928, he made his radio debut on the NBC series "The Intimate Revue," where he rapidly became a fan favorite due to his quick wit and comedic prowess. Encouraged by the success of his radio work, Hope began to make a name for himself in Hollywood, where he swiftly established himself as one of the industry's most in-demand performers. In 1934, he made his big-screen debut in the musical comedy "The Big Broadcast of 1938," launching a prolific cinema career that would last five decades. Hope's talent and versatility as a performer were fully displayed throughout his early career as he fluidly shifted between radio, film, and live engagements. Whether delivering one-liners on the radio or starring in

a blockbuster movie, he captured audiences with charm, charisma, and undeniable celebrity. Despite his success, Hope never lost sight of the principles that had guided him since the beginning.

Throughout his career, he was dedicated to using his platform for good, whether by raising donations for charitable causes or entertaining troops overseas during wartime. His persistent dedication to service and unshakeable resolve to make a difference in the world gained him the respect and affection of millions worldwide. By the time he died on July 27, 2003, at 100, Bob Hope had made an everlasting impression on the entertainment business and beyond. His contributions to humor, dedication to public service, and unwavering optimism continue to inspire generations of performers and viewers, ensuring that his legacy lives on for many years to come.

Creating a Comedy Empire

Bob Hope's rise to become one of comedy's most legendary figures resulted from a well-planned strategy, a tireless work ethic, and an unwavering commitment to greatness. From his beginnings in vaudeville to his reign as a Hollywood superstar, Hope built a comic empire that spanned generations and left an unforgettable effect on the entertainment business. Hope's comedic empire was built on a profound grasp of his audience and the ever-changing nature of humor. He realized early on that

comedy was a dynamic art form that needed ongoing creativity and adaptation to stay current. With this insight, Hope set out to master every aspect of comedy, from stand-up routines to slapstick humor, guaranteeing that he could connect with people of all ages and backgrounds. One of the foundations of Hope's comedic empire was his mastery of timing and delivery. Whether delivering a joke on stage or joking with guests on his radio and television shows, he had an unrivaled ability to make audiences laugh with a simple look or gesture. His perfect timing and razor-sharp humor were his trademarks, establishing him as one of the funniest men in show business. However, Hope's comedic empire was built not only on laughter but also on connections. Throughout his career, he surrounded himself with writers, producers, and actors who shared his vision and contributed to realizing his comedic brilliance. They collaborated to create some of the most unforgettable moments in entertainment history, ranging from his famed USO shows for troops overseas to his iconic Academy Award performances.

Another pillar of Hope's comedic empire was his ability to adapt to new media and technology. As radio gave way to television and movies, he embraced these new platforms wholeheartedly, employing them to reach wider audiences and spread his impact. Whether hosting his variety show or acting in blockbuster blockbusters, he repeatedly demonstrated that he was more than just a comic; he was an entertainment force. However, arguably, the most lasting impact of Hope's comedic empire was his persistent dedication to giving back. Throughout his career, he used his celebrity and money to assist philanthropic causes, raise donations for the less fortunate, and entertain troops stationed overseas during wartime.

His unwavering commitment to service earned him the respect and adoration of millions worldwide, cementing his place as a genuine American legend. By the time he died in 2003, Bob Hope had established a comedic empire that had transcended generations and touched countless lives. From his humble origins in vaudeville to his legendary stature as one of Hollywood's biggest stars,

he has a lasting effect on the entertainment business and the world. Even though he is no longer with us, his legacy lives on, motivating comedians and performers to follow in his footsteps and carry on the heritage of laughter and joy he relentlessly promoted.

CHAPTER 4

Refining the Craft: Developing Bob Hope's Persona

Bob Hope's humorous persona was carefully built over years of trial, error, and refinement. From his early days as a struggling vaudevillian to his reign as one of Hollywood's most beloved performers, Hope polished his comedic skills and created a persona synonymous with laughter and joy. Bob Hope's image revolved around his quick wit and biting tongue. Thanks to his

rapid-fire delivery and intelligent wordplay, he had audiences in stitches from the moment he appeared on stage. His ability to think on his feet and improvise at the moment distinguished him from his peers, earning him a reputation as one of the funniest men in show business. But Hope's humorous character was about more than just making people laugh; he wanted to connect with his audience on a deeper level. Whether mocking politicians, lampooning Hollywood personalities, or riffing on everyday life, he had a talent for finding humor in even the most commonplace situations and making people see the bright side of life. Self-deprecating humor was a fundamental component of Bob Hope's persona. Despite his celebrity and success, he never took himself too seriously and was always willing to poke fun at himself. Whether he made fun of his appearance, lack of musical ability, or multiple unsuccessful dating attempts, he won over audiences with humility and charisma. Perhaps the most enduring part of Bob Hope's persona was his unfailing optimism and indomitable energy. In a world full of negativity and cynicism, he was a light of hope and brightness,

reminding people that laughing was the best medicine and that no matter how awful things appeared, there was always something to smile about. Throughout his career, Hope honed and perfected his humorous image, continuously pushing himself to new heights and exploring new avenues of comedy. Whether hosting his television variety show, starring in blockbuster films, or entertaining troops overseas, he never rested on his laurels. He constantly looked for new ways to innovate and adapt as a performer. But perhaps the actual genius of the Bob Hope persona was its universality. Whether playing for troops on the front lines or entertaining audiences in their homes, he had a talent for connecting with people from all walks of life and making them feel like they were a part of the joke. His ability to transcend racial, socioeconomic, and national lines earned him global acclaim and cemented his place as a great American legend.

Notable Achievements in Radio, Film

Bob Hope's contributions to radio and film are legendary, with each medium highlighting his comedic abilities and cementing his legacy as one of the most adored comedians ever. Throughout his career, he set several records and left an everlasting impression on both industries, forever altering the entertainment landscape. Achievement in Radio: "The Bob Hope Show"One of Bob Hope's most important contributions to radio was the conception and success of "The Bob Hope Show." Debuting in 1938, the radio program immediately became one of the most successful and enduring shows of its day, lasting more than three decades and confirming Hope's status as a comic genius." The Bob Hope Show" was a variety show that combined comic sketches, musical performances, and celebrity guests.

Millions of listeners tuned in weekly to hear Hope's quick wit and captivating charisma as he delivered his signature one-liners and bantered with co-stars and

special guests. But what truly distinguished "The Bob Hope Show" was its ability to adapt and develop with the times. As the world changed around him, Hope embraced new technology and genres, seamlessly shifting from radio to television in the 1950s. His ability to remain relevant and connect with audiences of all ages made "The Bob Hope Show" a cultural touchstone, cementing his place as a true icon of American entertainment. Film Achievement: The "Road to..."

In addition to his popularity on the radio, Bob Hope significantly impacted movies with his classic "Road to..." series. The "Road to..." films, which he co-starred in with his friend and longtime collaborator Bing Crosby, were a series of comedy classics about the escapades of two clumsy pals as they traveled to exotic locations worldwide. The "Road to..." series began in 1940 with "Road to Singapore" and included seven pictures, including "Road to Zanzibar," "Road to Morocco," and "Road to Bali." The films, known for their clever banter, slapstick humor, and catchy musical numbers, were a hit with fans and critics, earning glowing reviews and

cementing Hope and Crosby's place as one of Hollywood's most beloved comic duos. The "Road to..." series' most impressive achievement, however, was its ability to transcend the bounds of traditional comedy and appeal to audiences of all ages and backgrounds. With their ageless humor and universal themes of friendship and adventure, the films captivated audiences worldwide and established an enduring legacy that continues to influence filmmakers and entertainers today.

Expand into Television and Other Ventures

Bob Hope's foray into television and other businesses heralded a new chapter in his legendary career, cementing his place as one of the most influential people in entertainment history. From pioneering television variety shows to successful ventures into business and philanthropy, Hope's influence went far beyond humor, leaving an enduring stamp on television and beyond. Entering Television: "The Bob Hope Show "Bob Hope's move to television was a natural step for the seasoned comedian, who had previously dominated radio and film with his distinctive wit and charm. In 1950, Hope made his television debut with "The Bob Hope Show," a variety show that showed his humorous abilities through sketches, musical acts, and celebrity guests."The Bob Hope Show" rapidly became a smash with audiences, attracting millions of people each week and receiving critical acclaim for its revolutionary format and groundbreaking humor.

From his legendary opening monologues to his memorable sketches and musical numbers, Hope grabbed audiences with his quick wit and boundless energy, cementing his place as a television star. However, what distinguished "The Bob Hope Show" was its ability to adapt to the shifting television scene and stay relevant in an increasingly competitive market. Hope embraced new technology and formats as the medium developed, experimenting with color television, live broadcasts, and special events to keep viewers interested and entertained.

In addition to his variety show, Hope appeared on several other television programs, including chat shows, sitcoms, and game shows. His seamless charm and contagious charisma made him a fan favorite with audiences and producers, cementing his place as one of television's most in-demand talents. Diversifying Ventures: Business and PhilanthropyAside from his work in television, Bob Hope expanded his interests into business and philanthropy, using his name and riches to make a positive difference in the world around him.

Throughout his career, he was actively involved in various commercial enterprises, including real estate, investments, and sponsorships, all of which contributed to the expansion of his empire and financial success. But probably the most critical component of Hope's expansion into new companies was his dedication to philanthropy and public service. Throughout his life, he used his platform to do good, raising millions of dollars for charitable causes and entertaining troops overseas during wartime.

His unrelenting dedication to duty garnered him countless decorations and accolades, including the Presidential Medal of Freedom, the United State's highest civilian honor. In addition to his charity efforts, Hope's activism and campaigning helped to shape public opinion and influence political debate. From his advocacy for civil rights to his attempts to promote international diplomacy, he used his celebrity and power to champion causes close to his heart, leaving a legacy of social responsibility and civic involvement.

The Patriotic Entertainer

Bob Hope's legacy as a patriot entertainer is as strong as his reputation as a comedy genius. Throughout his distinguished career, Hope's unrelenting dedication to serving his country and supporting the men and women in the armed services made him a popular figure among both troops and civilians. Hope's patriotism and commitment to those who served distinguished him as a true American icon, from his famed USO tours to his persistent attempts to boost morale during wartime.USO Tours: Bring Laughter to the Front LinesBob Hope's iconic USO tours were a defining feature of his career as a patriotic performer. Beginning in 1941 during World War II and for over five decades, Hope went on multiple overseas trips to amuse American troops stationed in distant, dangerous regions worldwide.

From the jungles of Vietnam to the deserts of the Middle East, Hope offered laughter and joy to many soldiers and women, giving them a much-needed break from the difficulties of war. Hope's USO concerts demonstrated

his unshakable devotion to serving his country and supporting those who risk their lives to defend freedom and democracy. Despite the inherent risks and challenges of performing in conflict zones, he remained committed to raising morale and lifting the spirits of troops sent far from home. His contagious energy, quick wit, and irresistible charisma endeared him to audiences of all levels and backgrounds, cementing his place in the hearts of soldiers, sailors, and airmen worldwide. Perhaps the most surprising feature of Hope's USO tours was their influence on the men and women who served For many troops, Hope's performances gave a brief respite from the brutal realities of battle, serving as a much-needed reminder of the power of laughter and togetherness.

His willingness to travel to the front lines and partake in the trials of military life won him over generations of service personnel, who saw him as a celebrity and a friend and ally in their hour of need. Increasing Morale During Times of WarIn addition to his USO trips, Bob Hope's radio and television programs helped improve

morale throughout wartime. During World War II, he conducted a series of radio shows called "The Pepsodent Show" that included special episodes honoring and supporting the men and women in the armed services. These broadcasts featured live performances by Hope and his celebrity guests, providing solace and inspiration to millions of listeners at home and abroad.

During the Vietnam War, Hope maintained his practice of supporting the troops by producing a series of TV specials titled "Bob Hope's Christmas Shows," which were broadcast from military outposts and aircraft carriers worldwide. These shows featured performances by renowned entertainers and appearances by celebrity visitors. They quickly became a favorite among military members and their families, offering a much-needed reminder of home during the Christmas season. But probably the most iconic of Hope's broadcast specials was his annual Christmas presentation, which he hosted from various military posts and locales worldwide for almost 30 years. These shows featured performances by renowned entertainers and appearances by celebrity

visitors. They quickly became a favorite among military members and their families, offering a much-needed reminder of home during the Christmas season.

CHAPTER 5

Bob Hope and the Military: A Lifetime Dedication.

Bob Hope's lifelong service to the military demonstrates his unrelenting commitment to serving those who serve. From his renowned USO tours to his relentless attempts to promote morale during wartime, Hope's relationship with the military community lasted decades. It made an everlasting impression on the hearts and minds of both service members and civilians.

His legacy as a patriot entertainer is one of unity, compassion, and steadfast support for the men and women who fight for freedom and democracy worldwide. Early Connections and Bob Hope's involvement with the military extends back to his early days as a struggling musician, when he began entertaining troops stationed overseas during World War II. 1941, Hope started his first USO tour, visiting military stations and hospitals in Europe and North Africa to cheer up servicemen and women stationed far from home.

His performances were an immediate hit with the troops, who were charmed by his quick wit, irrepressible charm, and sincere gratitude for their sacrifice. As the war raged on, Hope continued to visit military bases and conflict zones worldwide, giving laughter and joy to many service members and raising morale in the most challenging times. His USO presentations became a valued tradition among troops, who eagerly awaited his arrival and relished the chance to escape the hardships of war, even if only for a few hours. However, the most lasting influence of Hope's World War II-era USO tours was on the men and women who served. For many troops, Hope's concerts served as a much-needed reminder of home and a little break from the horrors of combat. His willingness to travel to the front lines and partake in the trials of military life won him over generations of service personnel, who saw him as a celebrity and a friend and ally in their hour of need. The Korean and Vietnam War Bob Hope's dedication to the military grew more vital in the years after World War II when he continued to entertain troops during the Korean and Vietnam Wars.

Despite the inherent risks and challenges of performing in conflict zones, Hope remained committed to raising morale and lifting the spirits of troops sent far from home. During the Korean War, Hope went on several USO tours to entertain American troops stationed in South Korea and other parts of Asia. His concerts provided solace and motivation to soldiers, many of whom were fighting a conflict largely unrecognized by the American people. Hope's readiness to highlight their sacrifice and thank their service boosted morale and reminded soldiers that they were not forgotten. In the years that followed, Hope maintained his practice of supporting the troops by hosting a series of televised specials known as "Bob Hope's Christmas Shows," which were broadcast from military outposts and aircraft carriers throughout the globe. These shows featured performances by renowned entertainers and appearances by celebrity visitors. They quickly became a favorite among military members and their families, offering a much-needed reminder of home during the Christmas season.

Bob Hope's legacy as a patriot entertainer is one of unity, compassion, and steadfast support for the men and women who fight for freedom and democracy worldwide. His lifelong commitment to the military community impacted the lives of countless service members and civilians, leaving an unforgettable imprint on the hearts and minds of those he entertained. In addition to his USO tours and television specials, Hope's radio broadcasts and public appearances helped boost morale during wartime. He never missed an occasion to express his gratitude for the sacrifices made by service members and their families, whether by presenting his radio show or participating in military charity fundraisers.

The Effect of USO Tours on Troops

Bob Hope's USO tours significantly impacted the troops he entertained and the public's opinion of the military. Hope's relentless efforts to promote morale and support the men and women of the armed services not only elevated spirits during wartime but also contributed to a greater understanding and appreciation for the sacrifices made by service personnel worldwide. His legacy as a patriot performer is friendship, compassion, and steadfast support for those who uphold liberty and democracy. Increasing Morale and Providing Respite Bob Hope's USO tours greatly impacted morale among overseas troops. For service soldiers far from home and enduring the difficulties of war, Hope's performances gave a much-needed break from the rigors of military life and a momentary getaway from the horrors of conflict.

His infectious energy, quick wit, and irrepressible charisma made numerous warriors laugh and smile,

lifting spirits and instilling a sense of camaraderie among those who served. However, perhaps the most remarkable aspect of Hope's USO tours was their ability to cross ranks, branches, and nationalities, bringing together service members from all walks of life and forming long-lasting bonds of friendship and camaraderie. Whether performing for soldiers, sailors, airmen, or Marines, Hope treated each audience member equally and appreciated, fostering a sense of unity and solidarity that transcended wartime divisions. Shaping Public Perception and Promoting Understanding In addition to impacting the troops he entertained, Bob Hope's USO tours helped shape public perception of the military and foster a better understanding of the sacrifices made by service members.

Hope's televised specials and radio broadcasts brought the realities of war into millions of Americans' living rooms, providing a glimpse into the lives of those who served and highlighting the challenges they faced daily. Hope contributed to the humanization of the military by highlighting service members' courage, resilience, and

humanity, as well as challenging stereotypes and misconceptions about the military.

His willingness to travel to the front lines and experience the hardships of military life increased Americans' appreciation for the sacrifices made by those who served, instilling empathy and gratitude for their service and dedication. Legacy and Continued Impact Bob Hope's legacy as a patriot entertainer inspires generations of performers and audiences, reminding us of the power of laughter and the importance of standing up for freedom and democracy. Hope's USO tours and other philanthropic efforts left an indelible mark on the hearts and minds of service members and civilians, leaving a legacy of camaraderie, compassion, and unwavering support for the men and women of the armed forces.

Honors and Recognition of Service

Bob Hope's USO tours significantly impacted the troops he entertained and the public's opinion of the military. Hope's relentless efforts to promote morale and support the men and women of the armed services not only elevated spirits during wartime but also contributed to a greater understanding and appreciation for the sacrifices made by service personnel worldwide. His legacy as a patriot performer is friendship, compassion, and steadfast support for those who uphold liberty and

democracy. Increasing Morale and Providing Respite Bob Hope's USO tours greatly impacted morale among overseas troops. For service soldiers far from home and enduring the difficulties of war, Hope's performances gave a much-needed break from the rigors of military life and a momentary getaway from the horrors of conflict.

His infectious energy, quick wit, and irrepressible charisma made numerous warriors laugh and smile, lifting spirits and instilling a sense of camaraderie among those who served. However, perhaps the most remarkable aspect of Hope's USO tours was their ability to cross ranks, branches, and nationalities, bringing together service members from all walks of life and forming long-lasting bonds of friendship and camaraderie. Whether performing for soldiers, sailors, airmen, or Marines, Hope treated each audience member equally and appreciated, fostering a sense of unity and solidarity that transcended wartime divisions. Shaping Public Perception and Promoting Understanding.

In addition to impacting the troops he entertained, Bob Hope's USO tours helped shape public perception of the military and foster a better understanding of the sacrifices made by service members. Hope's televised specials and radio broadcasts brought the realities of war into millions of Americans' living rooms, providing a glimpse into the lives of those who served and highlighting the challenges they faced daily. Hope contributed to the humanization of the military by highlighting service members' courage, resilience, and humanity, as well as challenging stereotypes and misconceptions about the military.

His willingness to travel to the front lines and experience the hardships of military life increased Americans' appreciation for the sacrifices made by those who served, instilling empathy and gratitude for their service and dedication. Legacy and Continued Impact Bob Hope's legacy as a patriot entertainer inspires generations of performers and audiences, reminding us of the power of laughter and the importance of standing up for freedom and democracy. Hope's USO tours and

other philanthropic efforts left an indelible mark on the hearts and minds of service members and civilians, leaving a legacy of camaraderie, compassion, and unwavering support for the men and women of the armed forces.

Personal Life and Challenges

While often overshadowed by his towering presence in the entertainment world, Bob Hope's personal life was marked by triumphs and challenges. From his humble beginnings to his rise to fame and fortune, Hope navigated the complexities of fame, family, and personal relationships with resilience and determination. Despite facing numerous obstacles along the way, he remained steadfast in his pursuit of happiness and fulfillment, leaving behind a legacy that transcends the glitz and glamour of Hollywood. Early Years and Family

Background Bob Hope was born Leslie Townes Hope on May 29, 1903, in Eltham, London, England, the fifth of seven sons born to William Henry Hope and Avis Townes Hope. When he was four, his family emigrated to the United States, settling in Cleveland, Ohio, where Hope spent much of his formative years. Growing up in a working-class neighborhood, Hope's childhood was marked by hardship and opportunity. His parents struggled to make ends meet, and Hope often found himself working odd jobs to help support the family. Despite these challenges, he remained determined to succeed and pursued his passion for entertainment with unwavering resolve.

Early Ambitions and Struggles From a young age, Hope showed an aptitude for performing and entertaining his classmates with impressions and comedic sketches. Inspired by the vaudeville acts he saw at local theaters, he began honing his craft as a teenager, performing in amateur talent shows and vaudeville revues. But Hope's path to success was not without its setbacks. He faced numerous rejections and setbacks in his early career,

struggling to find footing in the competitive entertainment world. Yet, despite these challenges, he remained undeterred, pushing himself to new heights and refusing to give up on his dreams. Marriage and Family Life In 1934, Hope married his longtime girlfriend, Dolores Reade, with whom he would share a loving and devoted partnership for over 69 years until he died in 2003.

The couple welcomed four children together – Linda, Tony, Kelly, and Nora – and remained committed to each other through the highs and lows of their personal and professional lives. Despite his demanding career and frequent travels, Hope always made time for his family, prioritizing their happiness and well-being. He cherished his role as a husband and father, and his family remained a constant source of love and support. Challenges and Setbacks Like many celebrities, Bob Hope faced his fair share of challenges and setbacks throughout his career. From professional disappointments to personal struggles, he navigated the highs and lows of fame with resilience and grace, refusing to let adversity define him. One of

the most significant challenges Hope faced was the loss of his son, Anthony, who died unexpectedly in 2004 at the age of 63. The loss of his beloved son was a devastating blow for Hope and his family, yet they found strength in each other and leaned on one another for support during this difficult time. In addition to personal losses, Hope faced criticism and controversy throughout his career, particularly concerning his political views and associations.

Despite facing backlash from some quarters, he remained steadfast in his convictions. He continued to use his platform to advocate for causes he believed in, including support for the military and veterans. Legacy and Enduring Influence Bob Hope's legacy is one of resilience, determination, and unwavering commitment to his craft and family. Despite facing numerous challenges and setbacks, he never lost sight of his goals or values, remaining true to himself and his beliefs throughout his life. Today, Bob Hope is remembered not only for his iconic performances and contributions to the entertainment world but also for his kindness, generosity,

and dedication to those in need. His legacy lives on through the countless lives he touched and the countless smiles he brought to faces worldwide, reminding us of the power of laughter, love, and perseverance in the face of adversity.

CHAPTER 6

Family and Relationships

Bob Hope's family and relationships significantly shaped his life, career, and legacy. From his enduring partnership with his wife, Dolores, to his close bonds with his children and extended family, Hope's relationships were a source of love, support, and inspiration throughout his life.

Despite the demands of his career and the challenges of fame, he remained committed to his family, prioritizing their happiness and well-being above all else. Marriage to Dolores At the center of Bob Hope's family life was his marriage to Dolores Reade, whom he wed in 1934 Their union would endure for over six decades as a testament to their deep love and devotion to each other. Dolores was not only Hope's wife but also his closest confidante, partner in life and business, and the mother of his four children.

Dolores played a pivotal role in supporting Hope's career and managing the demands of their busy family life. Despite the challenges of being married to one of the most famous men in the world, she remained a steadfast presence by his side, providing unwavering support and encouragement throughout their marriage. Parenting and Family Life Together, Bob and Dolores raised four children – Linda, Tony, Kelly, and Nora who would

become the center of their world.

Despite his demanding career and frequent travels, Hope made time for his family, prioritizing their happiness and well-being above all else. As a father, Hope was affectionate, attentive, and deeply committed to his children's upbringing. He cherished his role as a dad and took great pride in watching his children grow and succeed in their endeavors. Despite his fame and fortune, he instilled in them values of hard work, humility, and compassion, teaching them the importance of family and treating others with kindness and respect. Extended Family and Close Bonds In addition to his immediate family, Bob Hope maintained close ties with his

extended family, including his siblings, nieces, and nephews. Despite the demands of his career and the pressures of fame, he remained grounded in his roots and valued the importance of family connections. Throughout his life, Hope made time for family gatherings, reunions, and celebrations, cherishing reconnecting with loved ones and creating lasting memories. Despite his status as a Hollywood legend, he remained humble and approachable, treating everyone he met with warmth and kindness

Challenges and Setbacks

Despite the strong foundation of love and support provided by his family, Bob Hope faced his fair share of challenges and setbacks in his personal life. From losing loved ones to the pressures of fame and fortune, he navigated the complexities of family relationships with resilience and grace. One of the greatest challenges Hope faced was the loss of his son, Anthony, who died unexpectedly in 2004 at the age of 63. The loss of his beloved son was a devastating blow for Hope and his family, yet they found strength in each other and leaned on one another for support during this difficult time. 6.2 Navigating Success and Setbacks Bob Hope's life and career exemplify the quintessential American success story, punctuated by moments of significant challenge and extraordinary achievement. His journey through the entertainment world was marked by an unwavering work ethic, a knack for reinvention, and an innate ability to connect with audiences, even during the most turbulent times. To understand Bob Hope's legacy, one must delve

into the rich tapestry of his experiences, his resilience in the face of adversity, and his unyielding commitment to bringing joy to others. Born Leslie Townes Hope on May 29, 1903, in Eltham, England, Bob Hope's early life was far from glamorous. His family immigrated to the United States when he was four, settling in Cleveland, Ohio. Growing up in a working-class neighborhood, Hope developed a strong sense of determination and an early love for performing.

He entered various talent contests, honing his comedic skills and gaining the confidence to propel him to stardom. Hope's initial foray into the entertainment industry began in vaudeville, a popular theatrical genre. Vaudeville provided a platform for aspiring entertainers, and Hope seized the opportunity. His quick wit, impeccable timing, and ability to engage the audience made him a standout performer. However, the road to success was not without obstacles.

The vaudeville circuit was highly competitive, and Hope faced numerous rejections and less-than-enthusiastic audiences. Yet, each setback only strengthened his

resolve to succeed. He learned to adapt his style, incorporating new material and refining his comedic approach, which eventually garnered him a dedicated following. The transition from vaudeville to radio in the 1930s marked a pivotal moment in Hope's career. Radio was the preeminent medium for entertainment, and Hope's distinctive voice and humor quickly made him a household name. He secured his show, "The Pepsodent Show," which became one of the most popular radio programs of the time.

His ability to connect with listeners through the airwaves showcased his versatility and solidified his status as a top-tier entertainer. However, the competition was fierce, and maintaining high ratings required constant innovation and adaptation. Hope's success on radio paved the way for his entry into the film industry. The 1940s and 1950s were his golden years, as he starred in a series of successful films showcasing his comedic talents. His collaborations with Bing Crosby in the "Road to" series, including classics like "Road to Singapore" and "Road to Morocco," were particularly

well-received. These films combined humor, adventure, and music, creating a winning formula that captivated audiences. Despite his burgeoning film career, Hope remained grounded and committed to his craft, always seeking ways to improve and stay relevant. One of the defining aspects of Hope's career was his dedication to entertaining American troops during times of war. Beginning in World War II and continuing through the Korean and Vietnam Wars, Hope embarked on numerous USO (United Service Organizations) tours to bring laughter and a touch of home to soldiers stationed overseas.

These tours were not without risk; performing in war zones and under challenging conditions required immense courage and resilience. Hope's commitment to the troops went beyond mere performances; he spent time with them, listened to their stories, and provided a much-needed morale boost. His efforts earned him the nickname "America's No. 1 Soldier in Greasepaint" and solidified his legacy as a beloved entertainment and American culture figure. Hope's ability to navigate the

ups and downs of his career extended to his personal life. He married Dolores DeFina, known professionally as Dolores Reade, in 1934. Their marriage, which lasted until Hope died in 2003, was a cornerstone of his stability and success. Balancing a demanding career with family life was no easy feat, but Dolores provided unwavering support and managed their household gracefully. Together, they adopted four children, creating a close-knit family that remained a source of strength for Hope throughout his life. Philanthropy played a significant role in Hope's life. His entertainment success gave him a platform to give back to the community. He supported numerous charitable causes, including establishing the Eisenhower Medical Center in Rancho Mirage, California. His generosity extended to educational institutions, veterans' organizations, and various health-related initiatives.

Controversies and Criticisms

Bob Hope, an iconic figure in American entertainment history, is often remembered for his quick wit, comedic genius, and philanthropic endeavors. However, his long and illustrious career, which spanned vaudeville, radio, film, television, and live performances, had its share of controversies and criticisms. While he is celebrated for bringing laughter to millions and supporting U.S. troops, several aspects of his life and career have drawn scrutiny and provoked debate.

One of the most enduring criticisms of Bob Hope centers around his political affiliations and activities. Hope was a staunch Republican and an outspoken supporter of various conservative causes. During the Vietnam War, he was particularly vocal in his support of U.S. involvement, which alienated many who opposed the war. While appreciated by many servicemen, his patriotic USO tours were also seen by critics as tacit endorsements of controversial military policies. This alignment with conservative politics often put him at

odds with the evolving cultural sentiments of the 1960s and 1970s, leading some to view him as out of touch with the younger generation. Hope's humor itself has been another point of contention. His comedy, while groundbreaking in its time, often included material that would be considered offensive by today's standards. Jokes based on racial and ethnic stereotypes, as well as gender roles, were common in his routines. Although these reflected the era's mainstream comedic sensibilities, they have not aged well and are now critiqued for perpetuating harmful stereotypes. For instance, his portrayals of Asians and Native Americans in films and sketches were often criticized for their lack of sensitivity and reliance on caricature. Moreover, his jokes about women frequently reinforced sexist stereotypes, portraying them in a light that would be considered misogynistic today.

Furthermore, Hope's professional relationships have been scrutinized for allegations of unfair treatment and exploitation. Some colleagues and contemporaries have recounted experiences that suggest Hope could be

difficult to work with. There are accounts of him taking credit for others' ideas and not always giving due recognition to his writers and collaborators. Given the collaborative nature of comedy and entertainment, these allegations paint a picture of Hope as a figure who, despite his genial public persona, could be imperious and self-serving behind the scenes. Another layer of controversy surrounds his personal life, particularly his relationships with women.

Despite maintaining a public image of a devoted family man, there have been numerous rumors and reports of extramarital affairs. His marriage to Dolores Hope lasted nearly 70 years, but it was not without its strains. Biographers and journalists have suggested that Hope's numerous liaisons were an open secret in Hollywood, raising questions about the authenticity of his public persona versus his private behavior. While these allegations have not been definitively proven, they have contributed to a more complex and less flattering picture of the man behind the legend. Hope's real estate ventures have also come under scrutiny. Over the years, he

amassed a significant property portfolio, which included some high-profile and luxurious estates.

Critics have pointed out that his wealth and status allowed him to engage in practices that were not always transparent or fair. For example, there were instances where his acquisition of land and property faced opposition from local communities and raised questions about ethical conduct. While his business acumen in property development is often lauded, it also reveals a side of Hope that was keenly focused on personal financial gain.

In addition to his real estate dealings, Hope's role in shaping Hollywood's labor dynamics has been a subject of critique. During his career, he was known to have opposed efforts to unionize within the entertainment industry. This stance put him at odds with many of his peers fighting for better working conditions and fair pay. Some see Hope's resistance to unionization efforts as indicative of a broader reluctance to support initiatives that could disrupt the status quo from which he greatly benefited. Moreover, Bob Hope's legacy is further

complicated by his actions and comments during the civil rights movement. While he publicly supported civil rights in certain contexts, some view his commitment to the cause as inconsistent. For example, his willingness to perform at segregated venues early in his career and his failure to more robustly support civil rights legislation have been points of criticism. These actions, or lack thereof, suggest a pragmatism that prioritized his career over a firm stance on social justice issues.

Hope's interaction with emerging media also brought him criticism. In the latter part of his career, his attempts to remain relevant led to appearances and performances that many considered out of touch. Critics pointed out that his style of comedy did not evolve with the times, making his later work less impactful and sometimes cringeworthy. Some see his insistence on maintaining a traditional comedic approach, even as the landscape of humor changed around him, as a refusal to adapt and grow. In philanthropy, while Hope is lauded for his extensive charitable work, there are criticisms about the motivations and transparency of his efforts. Some

skeptics argue that his philanthropic activities were as much about maintaining his public image and staying in the spotlight as they were about genuine altruism. There are also questions about how the funds he raised were managed and allocated, with some critics suggesting that more could have been done given the vast amounts he could generate.

Bob Hope's influence on American culture and entertainment has been a double-edged sword. While he undoubtedly paved the way for many comedians and brought joy to countless people, the content and methods he popularized also entrenched certain cultural norms that are now seen as problematic. His brand of humor, which often included lampooning marginalized groups, set a precedent that future generations of comedians had to grapple with and move beyond.

CHAPTER SEVEN

Long-term Contributions to Comedy and Entertainment

Bob Hope, a comic and entertainment titan, made an indelible effect on the business over his almost eight-decade career with his unique approach to humor, persistent work ethic, and ability to adapt to numerous media. His legacy in comedy and entertainment is extensive, inspiring innumerable acts and defining the landscape of American entertainment.

Bob Hope was born Leslie Townes Hope on May 29, 1903, in Eltham, England. His family immigrated to the United States when he was four years old. Hope's early career in entertainment began with vaudeville, where he perfected his trade as a comic, developing a quick wit and a fondness for physical humor. His ability to connect with audiences via humor was evident from the start, and these early experiences paved the way for his future success.

One of Hope's most important contributions to comedy was his mastery of the monologue. In an era when comedians frequently used slapstick or situational humor, Hope's monologues were distinguished by their rapid-fire delivery, brilliant wordplay, and topical humor. He became noted for his ability to deliver punchlines with perfect timing, which would become his hallmark. This comic method was groundbreaking then, paving the path for other comedians to emulate and modify his style. Hope's impact may be seen in the work of succeeding comic luminaries such as Johnny Carson,

David Letterman, and Jay Leno, all of whom used monologues as a staple of their television shows.

Hope's contributions to humor extended beyond his performances. He was also a pioneer in employing writers to create his content, believing that a solid team of writers could improve his performance while keeping his humor fresh and current. This collaborative method became the industry norm, improving comedy's quality. Hope's writing staff comprised some of the brightest comic minds of the period, including Mel Shavelson, Norman Panama, and Larry Gelbart, all of whom had successful careers. Hope kept his humor fresh and inventive by appreciating and encouraging the role of excellent writers.

In addition to his career in vaudeville and on stage, Hope seamlessly transitioned to radio, the dominating form of entertainment in the 1930s and 1940s. His radio program, "The Pepsodent Show," premiered in 1938 and rapidly became one of the most popular. Hope's ability to adapt his humor to the radio medium, where visual jokes were not permitted, demonstrated his flexibility as a

comic. The show's popularity cemented his status as a national celebrity while demonstrating his ability to comprehend and capitalize on the varied needs of various entertainment channels.

Hope's shift to film was as successful. He appeared in over 70 films, including the famous "Road" series with Bing Crosby and Dorothy Lamour. These films blended comedy, music, and adventure in a novel and appealing way for spectators. Hope and Crosby's chemistry and improvised technique established a new standard for comedy duos in film. The "Road" films were economically successful and critically praised, influencing the buddy comedy genre and establishing a blueprint for many subsequent films.

Television gave yet another chance for Hope to reinvent himself and increase his impact. He was one of the first great stars to embrace the new medium, knowing its potential to reach a vast audience. His television specials, particularly his Christmas programs, became yearly traditions that audiences anxiously anticipated. These specials frequently included humor, music, and

famous guests, resulting in a variety of show styles that would become a fixture of television entertainment. Hope's ability to adapt to television kept him relevant even as the entertainment world altered.

Hope's effect on humor and entertainment extends beyond his contributions to various mediums, as seen by his passion for entertaining the military. Beginning with World War II and continuing through the Korean, Vietnam, and Gulf Wars, Hope's USO tours provided much-needed laughter and comfort to American soldiers stationed worldwide. These tours demonstrated Hope's unfailing support for the military and his devotion to utilizing his abilities to enhance the morale of those serving their nation. The legacy of these tours is profound, showcasing the ability of comedy to bring solace and a sense of normalcy in the most terrible of situations. Hope's commitment to the troops garnered countless medals and reinforced his image as a popular figure among military members.

Hope's contributions to charity and philanthropy further highlight his lasting effect on the entertainment business.

He was a diligent fundraiser for several organizations, notably those about children, veterans, and healthcare. His initiatives garnered millions of dollars and set a bar for celebrity engagement in humanitarian operations. Hope's humanitarian efforts highlighted how musicians might utilize their popularity for the greater good, motivating succeeding generations of performers to use their platforms to achieve positive change.

In addition to his professional successes, Hope's traits also contributed to his long reputation. He was noted for his professionalism, work ethic, and ability to interact with people from all walks of life. These traits attracted him to spectators and made him a recognized figure in the entertainment world. Hope's modesty and desire to encourage budding comedians further established his influence, as he regularly counseled and assisted those just starting their careers

Hope's effect spread to the larger cultural environment as well. He was a symbol of American hope and perseverance, particularly during national catastrophe. His sense of humor brought comfort and continuity,

helping to unite the country throughout difficult times. Whether via his concerts, military support, or humanitarian initiatives, Hope personified the spirit of giving and the power of laughter.

Furthermore, Hope's legacy is perpetuated by various accolades and honors for his services to humor and entertainment. He earned five honorary Oscars, including the Jean Hersholt Humanitarian Award, which recognized his charity efforts. Hope was also awarded the Presidential Medal of Freedom, the nation's highest civilian honor, in appreciation of his contributions to the country via entertainment and philanthropy. These honors demonstrate the widespread acknowledgment and admiration for his achievements.

Hope's influence on the entertainment business is also reflected in the institutions and programs that bear his name. The Bob Hope USO centers serve and entertain military troops and their families, carrying on his legacy of service to the armed services. The Bob Hope Legacy, a nonprofit designed to preserve and promote his

humanitarian and cultural efforts, guarantees that his impact is recognized for future generations.

Bob Hope's Impact on Future Generations.

Bob Hope, born Leslie Townes Hope on May 29, 1903, in Eltham, London, is a legendary figure in American entertainment history. Hope's career lasted over a century and left a lasting mark on many aspects of entertainment, including vaudeville, cinema, radio, television, and live performances. His impact on future generations is far-reaching, stretching beyond the entertainment business to philanthropy and cultural diplomacy.

Hope's early years were highlighted by a transatlantic relocation from England to the United States as a kid. The move to Cleveland, Ohio, was essential in developing his career. The Hope family suffered financially, so young Bob worked numerous jobs until establishing his footing in the entertainment industry through vaudeville. His quick wit, engaging demeanor, and unrivaled comic timing earned him a household celebrity. By the 1930s, Hope had moved into radio, perfecting his skill and establishing himself as a major comic.

World War II represented a watershed moment in Bob Hope's career, as his services went beyond entertainment to promote morale among American troops. His USO (United Service Organizations) tours became renowned, giving soldiers stationed in some of the most difficult settings on the planet a sense of home and fun. Hope's commitment to the troops did not end with the war; he maintained his deployments during the Korean War, the Vietnam War, and even the Persian Gulf War. This unrelenting dedication won him countless honors, including the Congressional Gold Medal and an honorary knighthood from Queen Elizabeth II.

Hope's impact on succeeding generations of artists may be observed in a variety of ways. As a pioneer in radio and television, he established the benchmark for the comic variety show format, which was widely replicated. Hope's radio and television programmed created a framework that shows like "Saturday Night Live" and "The Tonight Show" follow. His ability to combine humour with a diverse spectrum of guests, musical

performances, and sketches resulted in a dynamic and entertaining style that held audiences' attention.

In cinema, Bob Hope's collaborations with Bing Crosby in the "Road to..." series were essential works that influenced other comic duos. Their chemistry, timing, and ability to improvise established a standard for buddy comedy. Hope's self-deprecating humor and everyman attitude made him personable and enduringly popular, characteristics that other comedians would emulate and modify in their own ways.

Furthermore, Hope's work ethic and smooth shift between mediums proved the value of variety in entertainment. Modern artists such as Steve Martin, Robin Williams, and Billy Crystal have followed in Hope's footsteps, demonstrating their skills in stand-up comedy, cinema, and television. Hope's style of comedy, with its clean and universal appeal, impacted many comedians who aim to produce humor that crosses cultural and generational lines.

Bob Hope's charity efforts also established a precedent for subsequent generations of celebrities to use their platforms for good. His considerable engagement with the USO and other philanthropic organizations demonstrated the influence public personalities might have beyond their professional accomplishments. This legacy of celebrity charity continues today, with many artists actively involved in humanitarian endeavors and using their popularity to generate awareness and funding for various causes.

Furthermore, Hope's function as a cultural ambassador cannot be underestimated. His ability to offer joy and a sense of normalcy to troops in combat zones demonstrated the potential of entertainment to bridge cultural and emotional boundaries. This component of his legacy is echoed in modern projects in which artists perform in war zones or engage in global outreach programs, utilizing their art to promote peace and understanding.

Hope's impact grew to include television specials, notably his Christmas specials, which became a popular

tradition. These shows, which frequently included comedy, music, and poignant moments, established a standard for future Christmas programming. "A Charlie Brown Christmas" and "The Carol Burnett Show" were inspired by the warmth and humor that Hope brought to his holiday shows.

In addition, Hope's flexibility and longevity in the entertainment industry teach future generations a vital lesson. He changed, embracing new technology and venues such as radio, television, and live satellite transmissions. This capacity to remain relevant in a fast-changing profession serves as an example for artists who must negotiate the ever-changing media and entertainment scene.

Bob Hope's impact is also reflected in the various prizes and honors named after him. The Academy of Television Arts & Sciences presents the Bob Hope Humanitarian Award to those in the entertainment business who have substantially contributed to humanitarian causes. This award assures Hope's generous attitude and commitment

to philanthropic causes will continue inspiring future generations.

Hope's style of humor, marked by wit and brilliance without succumbing to vulgarity, established a high standard for comic quality. Many comedians have emulated his style, which aims to create intelligent and accessible comedy. The balance he struck between topical humor and timeless jokes ensures his work remains relevant and appreciated by new audiences

Remembering Bob Hope: Tributes and Memorials

Bob Hope, an icon of American entertainment, died on July 27, 2003, at the age of 100, leaving a legacy still celebrated and remembered through various tributes and memorials. Hope's contributions have been recognized in various ways, reflecting the profound impact he had on both the entertainment industry and American culture.

Hope's death marked the end of an era in Hollywood, and tributes began pouring in immediately worldwide. Celebrities, politicians, and ordinary fans expressed their memories and admiration for a man who brought joy to millions. President George W. Bush described Hope as a "great American patriot" who "lifted the spirits of servicemen and women for decades" and praised his unique ability to make people laugh while providing comfort during difficult times. Many people shared these sentiments, seeing Hope as more than just a comedian, but also as a symbol of resilience and optimism.

One of the most significant tributes to Bob Hope was his final resting place. Hope was buried at the Bob Hope Memorial Garden at the San Fernando Mission in Los Angeles, California. The serene and beautifully maintained garden offers a tranquil setting for fans and admirers to pay their respects. The memorial garden is adorned with plaques and inscriptions commemorating Hope's life and legacy, ensuring that his memory lives on for future generations.

In addition to his burial site, many public memorials and dedications have been established in Hope's memory. The Bob Hope Memorial Library, located in his hometown of Cleveland, Ohio, houses his work and memorabilia. The library offers a comprehensive collection of his films, radio shows, and television programs, along with personal artifacts that provide insight into his life and career. This institution not only preserves Hope's legacy but also serves as an educational resource for those interested in the history of American entertainment.

Another notable tribute is the Bob Hope Airport in Burbank, California, officially renamed the Hollywood Burbank Airport. The renaming of the airport, a major travel hub in the Los Angeles area, underscores Hope's status as a beloved figure in Hollywood. The airport features displays and exhibits dedicated to Hope, including photographs, memorabilia, and historical information about his contributions to aviation and his frequent travels to entertain troops around the world.

Bob Hope's impact on the military community is perhaps one of his most enduring legacies, and this is commemorated in various military museums and memorials. The National World War II Museum in New Orleans includes exhibits dedicated to Hope's extensive USO tours, showcasing his tireless efforts to entertain American troops during some of the darkest times in history. These exhibits feature photographs, film clips, and personal accounts from soldiers who experienced Hope's performances firsthand, illustrating the profound effect he had on their morale.

In Washington, D.C., the United States Air Force Memorial features a bronze statue of Hope, a fitting tribute to his contributions to the armed forces. The statue depicts Hope in a characteristic pose, holding a microphone and exuding the warmth and humor that endeared him to so many servicemen and women. This statue stands as a reminder of Hope's unwavering support for the military and his role in bringing a touch of home to those stationed far from their families.

Television specials and documentary films have also played a significant role in keeping Bob Hope's memory alive. Shortly after his passing, NBC aired a tribute special titled "Bob Hope: The First 90 Years," celebrating his extraordinary career with clips from his shows, interviews with colleagues and friends, and reflections on his impact. This and other similar programs have helped to introduce new generations to Hope's work, ensuring that his contributions to comedy and entertainment are not forgotten.

Bob Hope's influence on the world of golf is commemorated through the annual Bob Hope Classic, now known as the American Express. Held in Palm Springs, California, this PGA Tour event was founded by Hope in 1960 and continues to attract top golfers and celebrities. The tournament not only honors Hope's passion for golf but also serves as a major charitable fundraiser, supporting numerous causes that were close to Hope's heart. The event stands as a testament to his love of the game and his dedication to philanthropy.

In Palm Springs, where Hope maintained a residence, the Bob Hope House stands as an architectural landmark. Designed by famed architect John Lautner, the house is a striking example of mid-century modern design and serves as a reminder of Hope's connection to the area. Although it remains a private residence, the house is an iconic part of Palm Springs' architectural heritage, often featured in tours and publications celebrating the region's unique style.

Bob Hope's contributions to entertainment and his philanthropic efforts have also been recognized with numerous awards and honors. He received five honorary Oscars, the Kennedy Center Honors, and the Presidential Medal of Freedom, among many other accolades. These awards are often highlighted in exhibits and retrospectives that celebrate his life and work, providing a tangible record of his achievements.

In addition to physical memorials and tributes, Bob Hope's legacy is perpetuated through the countless comedians and entertainers he inspired. His pioneering work in radio, film, and television set a standard for

comedy that continues to influence performers today. Many comedians credit Hope as a significant inspiration, citing his timing, delivery, and ability to connect with audiences as qualities they strive to emulate.

The digital age has also played a role in preserving and sharing Bob Hope's legacy. Numerous online archives and streaming platforms offer access to his vast work, allowing new audiences to discover and enjoy his comedy. Websites dedicated to his life and career provide comprehensive resources, including biographical information, filmographies, and collections of his most memorable performances. Social media platforms have also become venues for fans to share their favorite Hope moments, keeping his memory alive in the digital sphere.

Educational institutions have also embraced Hope's legacy, incorporating his work and contributions into their curricula. Universities and colleges with film, television, and performing arts programs often study Hope's career as part of their coursework, examining his impact on the development of comedy and entertainment. Guest lectures, film screenings, and

academic conferences dedicated to Bob Hope provide opportunities for students and scholars to engage with his legacy meaningfully.

Hope's dedication to charity and humanitarian efforts is perhaps one of the most enduring aspects of his legacy. The Bob and Dolores Hope Foundation, established by Hope and his wife, supports various charitable causes, including education, health care, and the arts. The foundation's work ensures that Hope's spirit of giving lives on, making a difference in the lives of countless individuals and communities.

Remembering Bob Hope is not just about looking back at his illustrious career; it is also about celebrating the values he embodied—humor, resilience, generosity, and a deep commitment to bringing joy to others. His legacy is a reminder of the power of laughter and the impact one individual can have on the world. Through the various tributes and monuments given to him, Bob Hope's legacy remains, motivating future generations to pursue their passions and make a good difference in the world.

Moral and lesson learned from Bob Hope

Bob Hope, one of the most durable and beloved performers of the twentieth century, led a life filled with profound teachings and values that may inspire and lead us. His path from humble beginnings to becoming a renowned figure in comedy, movies, and philanthropy teaches many lessons about perseverance, devotion, humility, and the value of giving back. In evaluating his life and work, we may derive some significant principles and teachings that resonate beyond the domain of entertainment.

One of the most important lessons from Bob Hope's biography is the value of perseverance and hard effort. Bob Hope was born Leslie Townes Hope in Eltham, England, in 1903. His family immigrated to the United States when he was four years old. They settled in Cleveland, Ohio, and had major financial troubles. Hope took odd jobs at an early age to support his family. This early experience developed in him a strong work ethic

and a will to achieve, qualities that he would use throughout his career. Despite early disappointments and rejections in his pursuit of a career in entertainment, Hope's unwavering determination finally paid off. His path emphasizes the value of perseverance in the face of hardship, a timeless lesson for anybody aspiring to achieve their goals.

Another valuable lesson from Bob Hope's life is the need of adaptation and versatility. Hope's career encompassed vaudeville, radio, film, television, and live performances, demonstrating his adaptability to changing times and mediums. Vaudeville was a popular form of entertainment during Hope's early career, and he excelled at it. However, as radio became more popular, he successfully transitioned to the new medium, becoming a beloved radio star. Later, he ventured into movies and television, where he continued to delight millions. Hope's openness to embrace new possibilities and capacity to reinvent himself were critical to his long-term success in the entertainment industry. This flexibility is an important lesson in today's fast-changing

world, when the capacity to pivot and welcome new challenges is critical to success.

Bob Hope's legacy includes humility and an eagerness to connect with people. Despite his enormous success and recognition, Hope remained personable and grounded. He had an extraordinary capacity to connect with people from all walks of life, whether they were other artists, fans, or servicemen and women. His multiple USO trips throughout World War II, Korea, Vietnam, and the Gulf War demonstrate this characteristic. Hope's continuous attempts to amuse troops, frequently under dangerous and difficult situations, demonstrated his great appreciation and desire to give back. These trips were more than simply entertainment; they were also about expressing gratitude and offering consolation to individuals who were far from home. Hope's humility and genuine concern for others demonstrate the value of remaining grounded and giving back, no matter how successful one grows.

Bob Hope's life also teaches us the value of humor and hope. Throughout his career, Hope has utilized comedy

to offer joy and amusement to others, particularly during tough times. His sense of humor was frequently light-hearted and inclusive, aiming to uplift rather than offend. During World War II, his comedy offered much-needed relief for both troops and civilians, helping to improve morale and restore a sense of normalcy amid turmoil. Hope's capacity to find humour in difficult situations is a poignant reminder of the value of having a happy attitude even in the face of hardship. Humor can be a powerful tool for resilience, allowing us to cope with adversity and find joy in even the smallest moments.

Another valuable lesson from Bob Hope's life is the importance of hard effort and planning. Hope was noted for his thorough preparation and commitment to his trade. He spent endless hours preparing and honing his routines, ensuring his presentations were polished and professional. This degree of devotion is reflected in the quality and consistency of his work over the years. Hope's dedication to greatness emphasizes the necessity

of putting in the effort required to meet high standards, whether in entertainment or any other industry. It serves as a reminder that skill alone is insufficient; hard effort and preparation are required for success.

Furthermore, Bob Hope's humanitarian endeavors demonstrate the value of leveraging one's platform for good. Hope participated in a variety of humanitarian activities during his life. He supported various causes, including education, healthcare, and the arts. His donations extended beyond financial assistance; he actively participated in fundraising events and utilized his influence to raise awareness for vital causes. Hope's humanitarian legacy is a compelling example of how people may use their prosperity and exposure to make a big difference in the world. It reminds us that prosperity comes with a responsibility to give back and help those in need.

Bob Hope's narrative emphasizes the value of family and personal ties. Despite his rigorous work, Hope maintained a close and loving bond with his family. He was married to his wife, Dolores, for approximately 70

years, demonstrating their strong commitment and mutual support. Hope has mentioned his family as a source of strength and stability in his life. This emphasis on family and personal ties is a timely reminder of the necessity of cultivating and sustaining tight bonds with loved ones. Success and business successes are essential, but personal relationships enhance our lives and bring long-term fulfillment.

Furthermore, Bob Hope's ability to remain relevant throughout generations teaches us to stay current and evolve with the times. Hope's content was constantly updated during his lengthy career, and he was aware of the societal developments that were occurring around him. He was able to connect with people of all ages by tackling modern topics and infusing current events into his humor. This capacity to remain relevant is critical in any sector since it necessitates continuous learning, adaptability, and a drive to innovate. Hope's lasting appeal indicates that being current does not imply abandoning one's roots but rather growing while remaining faithful to one's fundamental beliefs.

Finally, Bob Hope's legacy demonstrates the long-term influence of a life committed to spreading joy. Hope's primary purpose was to amuse and make people happy, which he accomplished in extraordinary ways. His work provided millions with joy and comfort, and his charity endeavors had a tremendous beneficial influence on many people's lives. Hope's legacy exemplifies the immense impact that one person's commitment to spreading pleasure can have on the globe. It teaches us that our acts, no matter how modest, may have a far-reaching impact and result in long-term good change.

www.ingramcontent.com/pod-product-compliance
Lightning Source LLC
Chambersburg PA
CBHW071933210526
45479CB00002B/661